6 $\underline{50}$

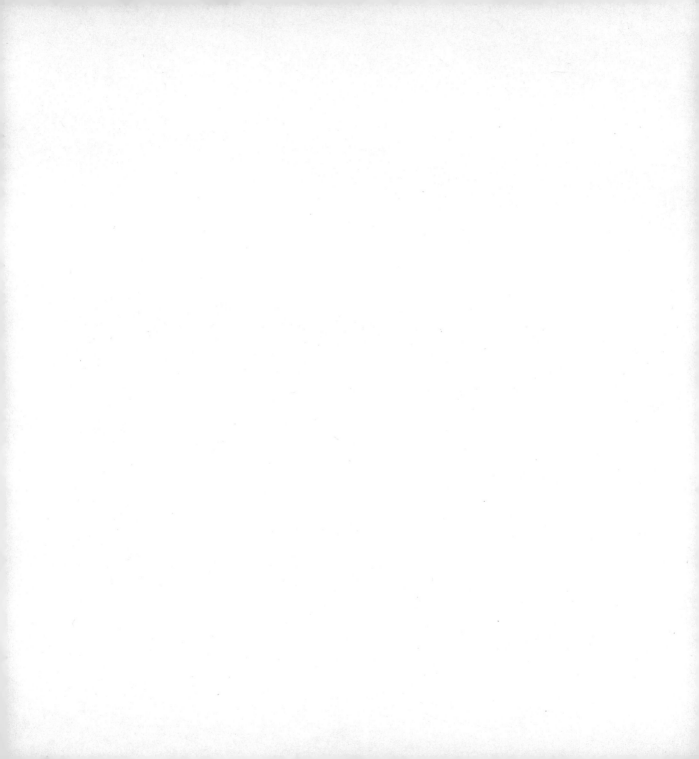

ADAM AND EVE

Willie Rushton
and the artists of the Portal Gallery

Bell & Hyman

Original paintings by the artists represented in this book are available through The Portal Gallery Ltd, London, UK.

Published in 1985 by
BELL & HYMAN LIMITED
Denmark House
37-39 Queen Elizabeth Street
London SE1 2QB

British Library Cataloguing in Publication Data

Rushton, William
Adam and Eve.
1. Adam (Biblical character) 2. Eve (Biblical character)
I. Title
222'.110922 BS580.A4

ISBN: 0 7135 1437 X

Designed by Colin Lewis

Typeset by Solecast 85, London

Colour separation by Positive Colour Ltd., Maldon, Essex

Produced in Great Britain by Purnell & Sons Ltd., Paulton

And God planted a garden eastward in Eden ...

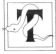

THOUGHTS ON ADAM AND EVE

The first thing that strikes you as odd about Adam and Eve are their names. Given that in the order of things they are, apart from God, first on, their names are somehow distinctly unbiblical. Adam and Eve. As I write I can hear quite clearly in the mind's ear some distant Sloane Ranger calling upstairs to her mate, in a voice that can down a bat at five hundred yards, "Darling! Adam and Eve are coming to din-dins on Thursday with Tarquin and Melissa!" Adam is something in the City or something else in Advertising. Eve is into Aerobics, bathes in Muesli and behaves in the main like Princess Di or some breathless blonde in an After Eights Commercial.

To be fair this Adam and Eve, with their bijou cottage somewhere in Chelsea, would not have named their children either Cain or Abel, certainly not both. It is also extremely unlikely that one would have become a keeper of sheep and the other a tiller of the ground, though he might I suppose have gone into Landscape Gardening.

In fact there was a third son, Seth, and one can see that name in the Births Column of the Times — "To Adam and Eve Blah-di-Blah of 43, Mary Quant Mews, SW3, a son, Seth" — though the Old Adam, and so much for talk about his erupting, was 130 when his Seth leapt from the womb. Admittedly, this occasion seems to have acted like a china egg, and during the last 800 years of his life, Adam and Eve begat like crazy.

Incidentally if anyone ever tells you the world is mad, express no surprise, and simply point at once to the intensive in-breeding from the word go.

FURTHER THOUGHTS

I think we'd better establish pretty quickly that Adam and Eve are fictitious and bear no resemblance whatsoever to any persons alive or dead or living in Chelsea. Except in America where millions have gone quite potty and been born again all over the place. President Reagan himself (who may well crack Methuselah's record of 969 years) is firmly convinced that He created the lot in 7 days. This view may be coloured by the fact that he (with a small 'h') can end it all in about three-and-a-half minutes.

I read recently of the hazards of taking the Old and New Testaments too literally. St Mark, for instance, says that believers "shall take up serpents" — possibly, I suppose, as a hobby. However, in the Appalachian Mountains in America this is taken as gospel, and death by snake-bite among believing hill-billies is reaching epidemic proportions.

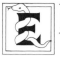 # EN PASSANT

I was wondering idly what I would have come up with had the Portal Gallery asked me for an 'Adam and Eve', and why they didn't I have no idea. For while I like to think I'm not naive, by Jove, bring me eight large gins and I'll show you primitive.

At one time or another, most of the Greats have had a crack at Adam and Eve, and set them in the main in contemporary settings. Probably it was as good an exercise as any for getting a nude woman into the house. It can be no coincidence that in many editions of the Old Testament Eve first leaps into view on Page Three.

I fancy I would work on the logical assumption that had Adam and Eve existed they would have looked truly primitive — Neanderthal yet. They would have had fine lumpy foreheads, prominent and disgusting teeth protruding over no jaw to speak of; they would have been covered in hair, shambled about with something of a stoop, the backs of their hirsute hands scratched and seamed from constant contact with early gravel. The Garden of Eden would have been quite exotic, with bubbling geysers and flashes of distant volcanoes through the dinosaur-gnawed shrubbery. The sky would have been red. My word, I can hardly wait to get the oils out. The serpent will obviously be some sort of dinosaur. I have no idea at all as to what to do about the apple. Perhaps some great mutant fruit about the size of the Isle of Wight.

Perhaps it would be easier to do a couple of nudists at Kew Gardens. Tell the truth, I'll dress them. Nudes are easier with clothes on, and anyway my flesh-tints tend to end up muddy. This would be all right, but Adam and Eve seem to be traditionally Caucasian.

 # YOU ARE HERE

There seems to be some sort of doubt as to the precise geographical location of the Garden of Eden. Everyone knows that it was to the west of the Land of Nod, which doesn't help at all. However, if you repair to Genesis, you will see that "a river went out of Eden to water the garden; and from thence it was parted, and became into four heads". The first of these rejoiced in the name of Pison (a cheerful rejoinder in my view to the opposing sentiment) which, as you may know, "compasseth the whole land of Havilah", the second was the Gihon and that surrounded Ethiopia, the third the Hiddekel, which is in the East of Assyria and the fourth was the Euphrates. Now pull out any decent map of the period and you will see that it could be anywhere in what we now refer to as the Middle East, before throwing ourselves into the nearest dug-out.

So there you are, now you know. It may just help when you're painting in the background. Think Oasis (Eden) and barren desert (north of Nod).

HE STORY SO FAR

Perhaps I should run through the plot. There are many of you who may have forgotten the official story of our formative years. Those of you who tend towards the theory of the Big Bang can read something else for a moment or so.

GOD'S WEEK

Monday
Heaven and Earth. Night and Day (also Cole Porter).

Tuesday
Firmament.

Wednesday
Particularly busy: Earth, Seas, Grass, Herbs, Fruit Trees and Seeds.

Thursday
Sun and Moon, and stars also.

Friday
Fish and Fowl. Great whales and every living creature that moveth.

Saturday
Beasts of the Earth, Cattle, Creeping things, Man.

Sunday
Feet up.

Monday
Adam given job in garden and firm warning re Apple. After lunch: God muses on the fact that Adam is alone and that this is not right. Makes note to make him an helpmeet.

Tuesday
God brings every beast of the field, and every fowl of the air to Adam "to see what he would call them. And whatsoever Adam called every living creature, that was the name thereof." Here we were very lucky as he was 100% right. Had he pointed at a passing sparrow and shouted "Herring", or hooted "Owl!" after a herd of bison, life as we know it would be even more confusing than it is.

The interesting moment is after this quiz when Genesis, having reported his success with cattle, beasts of the field, fowls of the air etc., says "but for Adam there was not found an helpmeet for him". So! that second Tuesday afternoon in the History of the World quite clearly God's thinking was that Man might well find his mate among the beasts or the fowls or indeed cattle. Luckily for Man, God then created Woman, but it must have been a close call. She could have been a wart-hog. Or a lark.

"And they were both naked, the man and his wife, and were not ashamed."

Wednesday
Enter left: the Serpent, ("more subtil than any beast of the field"). In a pretty un-subtil exchange with Eve, he persuades her to chomp on the Forbidden Fruit, and give Adam a bit. "The eyes of them both were opened, and they knew that they were naked; and they sewed fig leaves together, and made themselves aprons."

Thursday
God spots the aprons, and is thoroughly irked. Reduces the snake to ranks — "Upon thy belly shall thou go" — suggesting that at one stage it had legs. (The dinosaur theory?) Ejects Adam and Eve with a few sharp words, and a pair of fur-coats.

And off they went and began to begat.

HAT IS A PRIMITIVE?

Rather as the original Adam and Eve bred prodigiously, I always imagined that there was also this great family of primitives raised by the Adam and Eve of Naive Painting — out of Grandma Moses by L.S. Lowry. There is, but I've never been certain 'naive' was the word. According to *Chambers* — NAIVE (see NAIF) means "with natural or unaffected simplicity — esp. in thought, manners or speech; artless; ingenuous." Rubbish! These people know what they're doing. However and alas, it's in the nature of things that we must all be labelled. Left or Right, In or Out, U or Non-U, With It or Past It. Glamorous 23-year-old or Clapped-out 47-year-old, Sophisticated or Naive. All right, I'll go along with the word, but artless they aren't.

I like to think their spiritual leader is dear old Rousseau, for whom I have a lot of time. One would like to feel that each of those represented in this book would doff his or her beret at Le Douanier's shrine.

It is said that during a binge, Rousseau, primitive as a newt, took Picasso aside and announced "We, my good Picasso, are the two greatest painters of the age, you in the Egyptian style and I in the modern."

Go on, doff your berets. He is the daddy of them all.

Love
Willie Rushton
(self-taught)

FRED ARIS

EDENIC IDYLL

I'm standing here admiring this, worrying slightly perhaps about Adam who bears a striking resemblance to Anna Raeburn, and thinking that if this is an idyll they could look a deal more cheery, when I feel a savage dig in the ribs.

It is a vicious little old lady in pebble glasses, wielding an umbrella.

"Umbrellas" I say, pompously, "are not allowed in Art Galleries."

"This is not an Art Gallery" she snarls, "this is a book."

I am obliged to accept this and return to the business in hand. Perhaps, my thoughts continue, laughter as such came after the Fall. She thrusts a catalogue into my hand.

"Read it out" she says, "I can't see a thing in these glasses."

"Fred Aris" I reply "taught himself to paint. He owns a cafe in South East London. He is described as one of the most remarkable naive painters in Britain today."

"Very nice" she beams.

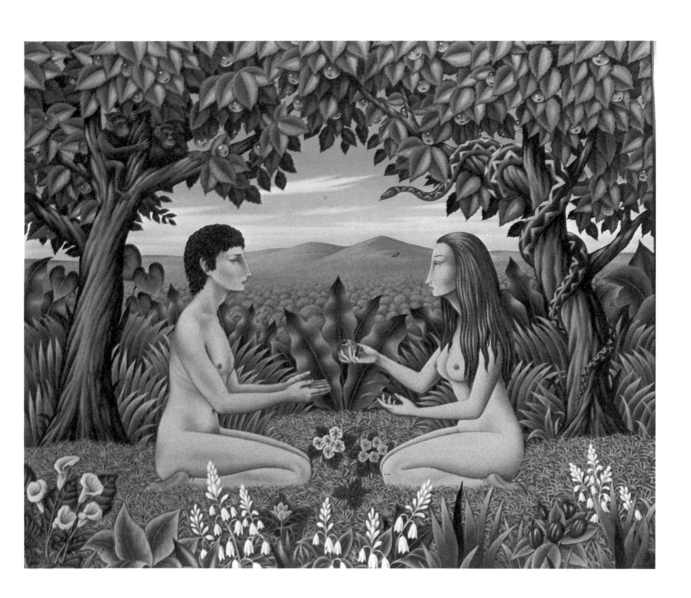

PATRICIA NEVILLE
EXOTIC VISION

"Very nice too" says my new friend, her pebble-glasses pressed to Adam's nether regions.

"Exotic is the word" I say, waving cheerfully to Eve up the tree.

"Indeed, it says here that Patricia Neville enjoys the exotic, and in my view, it shows. Painting," I continue, "was her first love."

"Was?" squeals Mrs Bradley, for it is she.

"Well, she married and had eight children" I reply "which leaves, one imagines, little time to dabble at the palette."

"Anything else?" Mrs Bradley is a beaver for information.

"It says here," and I can't help laughing, "her other great interest is English eccentrics."

Oh, Patricia, you'd rejoice in Mrs. Bradley. What a pity she's fictitious. Incidentally, I'm very fond of the disapproving heron bottom right.

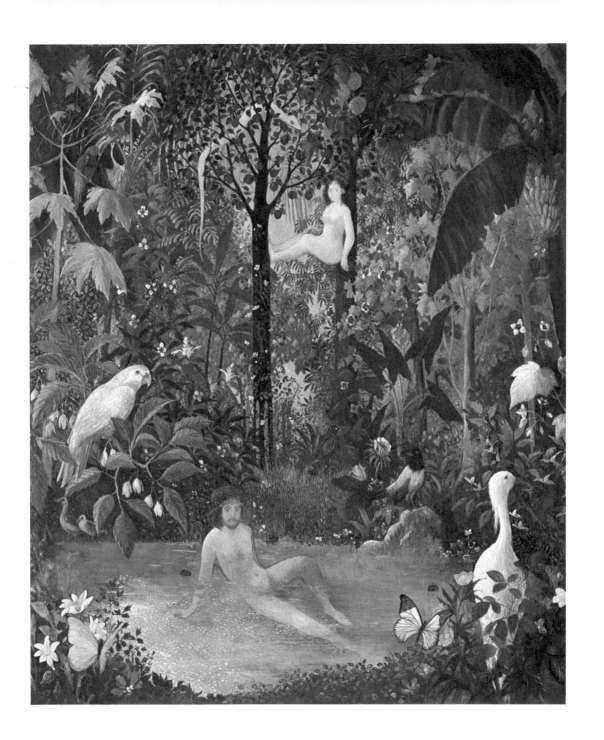

NEIL DAVENPORT
ON THE WAY OUT

While Mrs Bradley peered happily at the blur in front of her, I read Neil Davenport's comments to her.

"The way in and out of the Garden of Eden is a *fin de siècle* Metro station. Eden is a charming garden, perhaps the Eden Roc Hotel at Cap Ferrat. Eve, clearly an outrageous flapper, has been tempted to eat the forbidden fruit by the snake who has wound himself around the metro entrance in a decoratively art nouveau manner. Adam (Errol Flynn in leopard-skin leotard) and Eve, guiltily holding the apple, are politely being shown the way out of Paradise by an angel with a flaming sword in a full chauffeur's uniform."

"Errol Flynn has only got one leg" she complains.

"Why not?" I reply. "Artistic licence. I think it shows a certain generosity as most of the time Errol was legless."

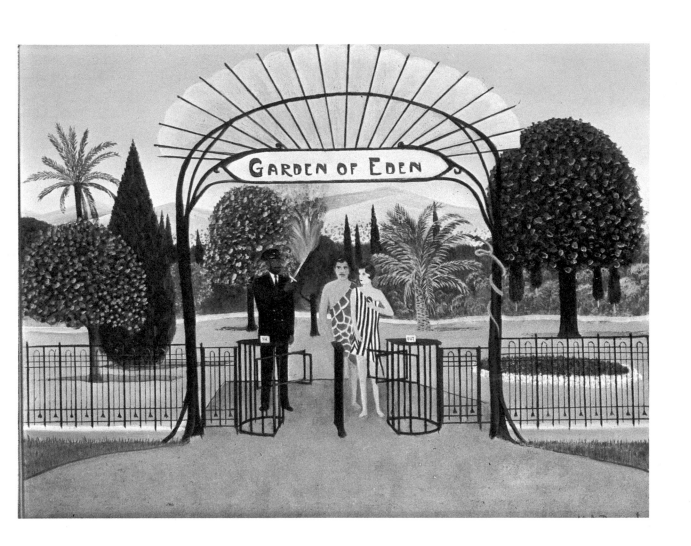

BERNARD CARTER

ALL ABOARD

"Bernard Carter" I read out loud "was born in 1920, has been a school-teacher and curator of paintings at the National Maritime Museum in Greenwich. He loves our waterways and rivers and will toss an old barge into a painting at the drop of a hat — and why not?" This was to forestall any further complaint, as having failed to see the frolicking nudes she thought Bernard was suggesting that Adam and Eve were chickens.

"Even" she snarled "Charles Darwin never went that far." She was stabbing at the chicken again with her umbrella, so I sat her down and read her the rather charming story Bernard tells about the picture.

"My painting is based on a true incident which happened to two friends. They were spending their honeymoon on a longboat on the river. It was a hot midsummer evening so they'd chosen a quiet spot to have a picnic in the nude on the grassy shore. The atmosphere was romantic — the moon shone, owls hooted, water lapped onto the banks, and sleeping swans tucked their heads under their wings. Suddenly a figure emerged from the rhododendron bushes. It was a drunken fisherman. Shining his torch full on them he said 'Another fifteen like me are coming this way any minute. You'd better run for it'."

14

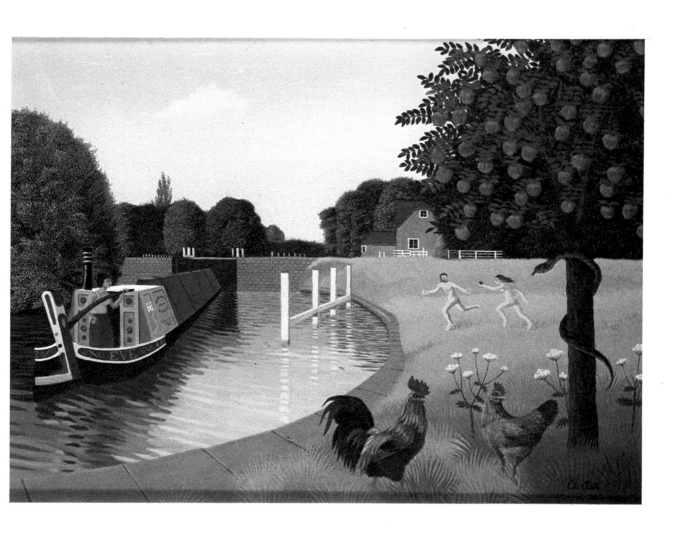

BERYL COOK

TEMPTATION

The heron is still looking disapproving and this is another picture. Mrs. Bradley is chortling with glee.

"Aha! Aah! Ahahaha!" she goes "Beryl Cook! Beryl Cook!" There's fame. It couldn't be anyone else.

"Always raises a smile" says the little old chortler. "Look at those birds."

"She didn't do her first picture till she was 37" I read. "Another late starter. Like Le Douanier. Can you be a late starter *and* a primitive?"

I left the silly question hanging there. They still haven't sold it.

"She was in Rhodesia and did a portrait of local women, armed only with a child's paint-box. Then she came back to England and became landlady of a boarding-house in Plymouth. There she was discovered, given her first London exhibition by the Portal, and the rest is history!"

"Look at those birds." She was still chortling. Through the chortles I read her some original Beryl.

"This was my first attempt at Adam and Eve. I have painted them since and also I once embroidered them on a cushion cover — mainly so I could give Eve a luxuriant growth of ginger curls — my favourite. Adam caused me rather more trouble but I finally managed to place him in this rather tasteful gesture surrounded by Passion Flowers. I think I must have been very keen on birds when I painted this picture." I am always amazed by the hardiness of Passion Flowers. They look so frail.

"Beryl and I have something in common." I say, proud as a parrot, "We've both done covers for *Private Eye.*"

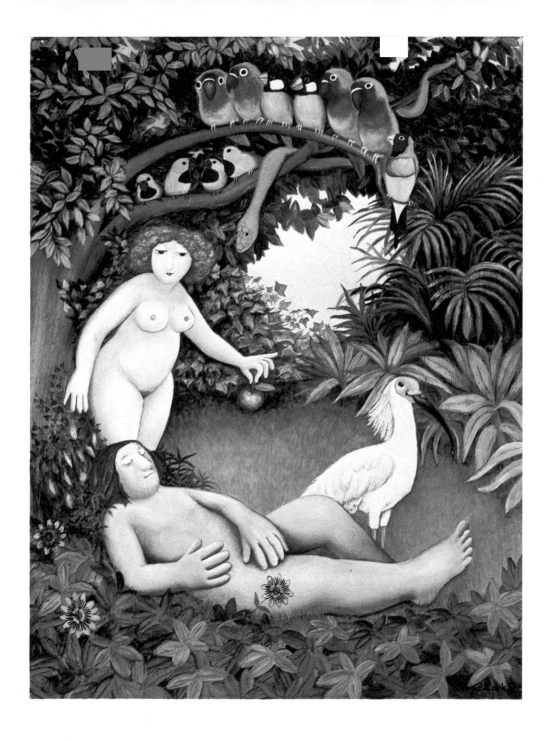

ANDREW MURRAY
SLEEPING SPOUSE

"You'll know this gentleman too, I think," I say. "Apart from anything else, you will have seen those excellent views he does of London, the Natural History Museum that sort of thing, you've seen them on postcards."

"I live in London. Who, pray, is going to send me a postcard of it?"

"You may, then" I riposte gamely "have known his grandfather, Sir James Murray, who edited the *Oxford English Dictionary*."

"That's another matter." She leers and winks, "Isn't Adam hairy?"

Is this the moment that Eve erupts from his rib-cage? The beasts certainly look surprised. I think, in fact, it's Adam's other famous nap. The serpent has just hissed, "Hey, baby, wanna know everything?" Eve looks suitably shocked.

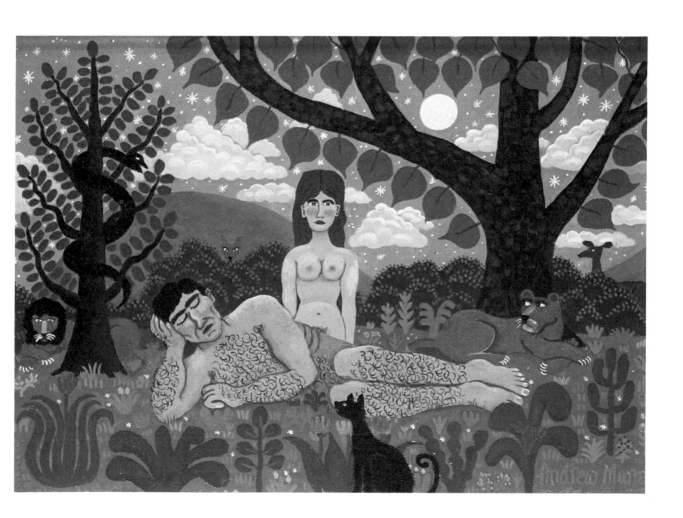

RON COPAS
THE FALL

I hear Mrs Bradley scream. She has vanished round a corner and I was dallying in the hope that I had lost her.

"What's that?" I hear her squeak, and as I have her catalogue I feel bound to help.

"What's what?" I ask. She stands transfixed. I'm not sure whether she was startled by the serpent's head, strangely reminiscent of something you might catch on the 'House of Lords Show', or its fearsome humanoid buttocks.

It was the wings that had alarmed her. She has a fear of bats. Particularly those as large as her.

"My word" I say, "there's some painting going on there." And ideas. Eve's dress and the tree. Adam dressed as the back half of the cow on the right. Those feet, straight from 'The Horse's Mouth'.

I thought for a moment Mr Copas was a cheat, as far as being primitive was concerned, for he won a scholarship to an Art School. But no, his parents could not afford to send him there. Instead he went to Cornwall, and became a boatman.

"I wonder if he would have come up with that if he'd been at Art School?" I muse out loud.

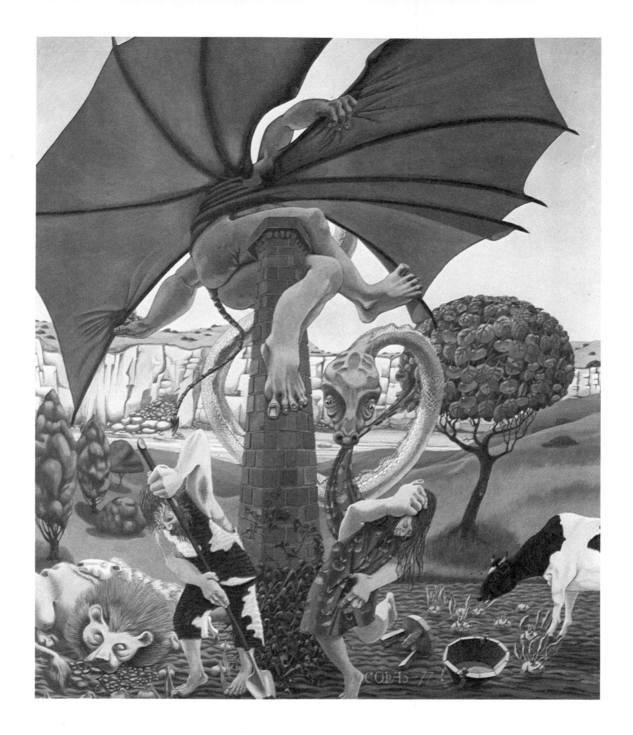

MARTIN LEMAN

FIRST LOVE

Now she's tut-tutting very loudly.

"Mr Leman," I say, "is well-known for his cats." I don't know why I think this will help. "*World* famous."

"Tut-tut-tut."

"He loves chess."

There is no way I am going to persuade her that these are two cats playing chess.

"Martin Leman" I read out loud "often deals with the naughtiness of sex. He was born in 1934. His father was a fruit merchant in Covent Garden."

None of this seems to help. She has removed her pebble-glasses and is doing a lively impersonation of Mother Whitehouse at her worst. All right, Martin Leman, you explain it to her.

"When I thought about how I was going to paint Adam and Eve, rather than show them standing apart as they usually are, I thought I would prefer a more romantic pose, showing the two figures — male and female — interlocked. In my picture, Eve is lying on some lush green grass in the Garden of Eden. She is holding a beautiful rosy apple — it's a symbol to make sure the spectator knows the painting is definitely Adam and Eve. Adam doesn't seem too interested in the tempting fruit — I'm afraid he is rather susceptible to female charm. In spite of her closed eyes, Eve has a rather smug expression — she knows she has got him just where she wants him."

What has always caused me to marvel is how they got it right first time. I mean, it's not an easy technique to master at the best of times, and there were no manuals in those days. This is certainly not a subject I intend to debate with Mrs Bradley.

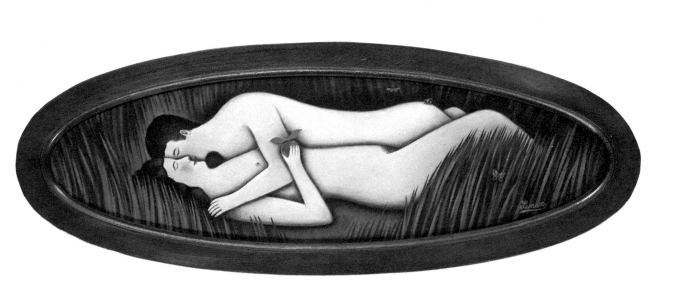

PATRICIA DEHO
SUNSET STRIP

I like the Sunset, I'm uncertain about the Strip. Eve has not yet taken the fatal nibble, there's the apple still sitting there top right, so she has nothing in fact to remove. Admittedly, after the Fall, even Gypsy Rose Lee would have been hard-pressed to muster much of an act, with only a fig leaf to work with.

Mrs Bradley likes this one, if that's any comfort. She likes the possum up the tree, or is it a sloth upside-down? There is something almost Disneyesque (and none worse for that) about Adam and his dog.

"Patricia Deho" I whisper into Mrs Bradley's good ear "was brought up in a small village near Wigan. (The Rushtons came from Wigan so there is a bond.) "She now works as a telephone operator in London." "Adam and Eve didn't have telephones" says Mrs Bradley wisely.

"Hence the name Paradise" I reply, even more wisely.

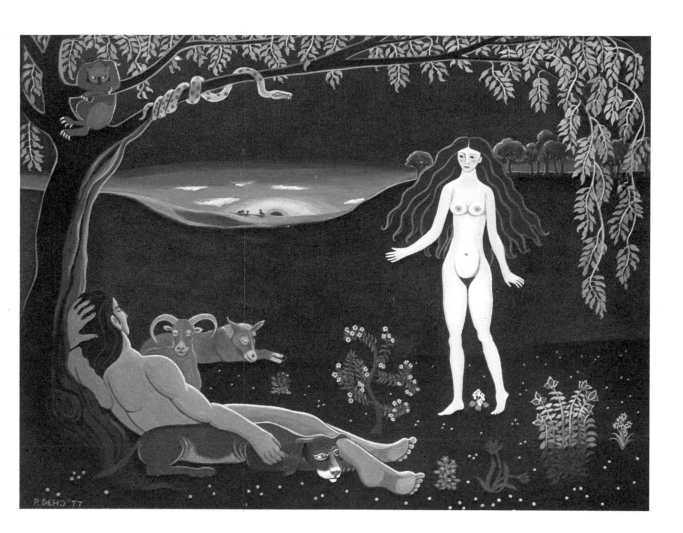

ADAM NAMING THE ANIMALS

The historic moment of which I spoke; Eve is on the scene a good day early but who cares?

"I do" says Mrs Bradley.

"Well you shouldn't," I snap. "Artists can do what they bloody well like. Otherwise they might as well be chiropodists."

I think it says much for the human spirit, and particularly Pearl Hessing's that here you have this supremely cheerful picture, full of hope and colour, and then read that she suffered most horribly under the Nazis before and during the Second World War. She is Austrian, but succeeded in emigrating to Australia after the War, then in 1962 came to London and started to paint. I hope she won't take offence if I say she was a later starter than most.

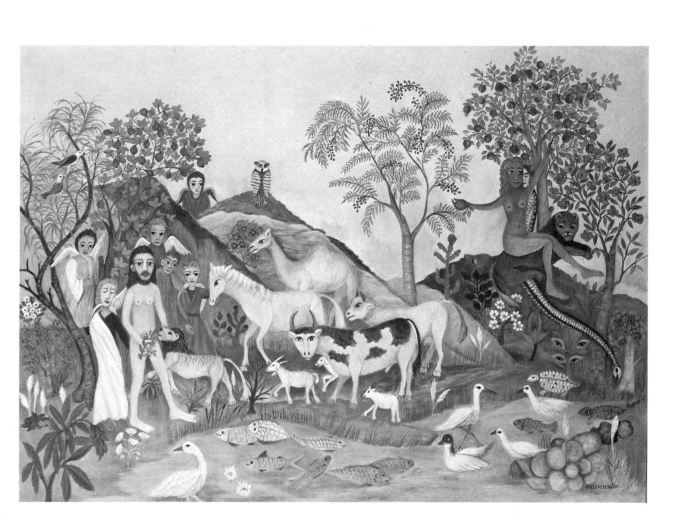

SHORT AND SWEET

"Short and Sweet." I say.

"Thank you" says Mrs Bradley, blushing to the roots of her blue wig.

"A touch of the Modiglianis, I would say" I say "and our first swimming-pool." But then Mr Dempsey is a plumber. Though better-known perhaps for the illustrating of best-selling paperbacks.

"Who's been trying to get in?" cries Mrs Bradley, pointing at the ladder against the outside of the barbed-wire topped wall. I thought she couldn't see.

"Well, there's no sign of the serpent" I reply helpfully, thinking it unlikely to be the Bermuda-shorts salesman. "Mr Dempsey," I add, "was born in Dagenham."

"Famous place to be born," she says. "Ford's Motor Works, The Girl Pipers."

"Cleo Laine," I say "Dudley Moore."

"And Mr Dempsey" she says.

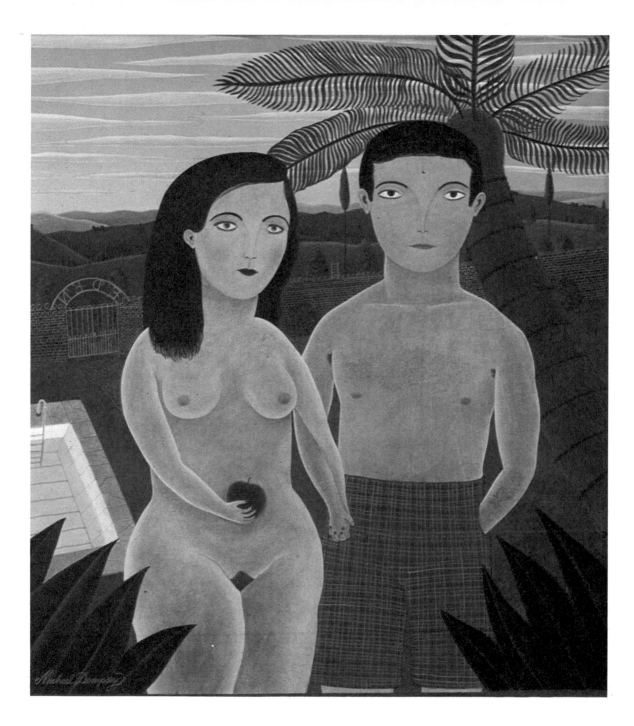

DORA HOLZHANDLER
EXOTIC AND EROTIC

"Exotic and Erotic," I say.

"Thank you," says Mrs Bradley, and even the blue wig reddens.

"Born in Paris. Lives in Scotland," I read, and then "Her work has been compared to that of Chagall." Which is faintly annoying, as I was about to say that.

I am particularly taken with the fish, and what a good way of doing water. I find water very difficult. Mrs Bradley spends many happy moments picking out the various beasts.

"She's got a sense of humour," she says.

In point of fact it's not very erotic. Exotic, perhaps. Funny.

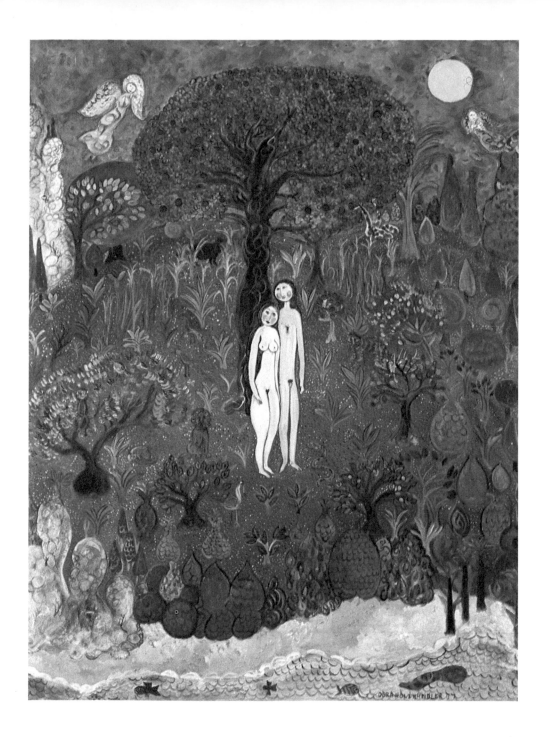

BARRY CASTLE
CLIMBING HIGH

"Firstly, perhaps, I should tell you that Barry Castle is a woman, a Dublin woman, née Finbar. She is married to another artist, Philip Castle."

Mrs Bradley likes it. Eve shinning up the tree like a native lad after coconuts.

I admit, out loud, that you certainly get your money's worth with the primitives. Not a detail is spared. Adam kipping in the bandstand; if you can have a swimming-pool in Eden, you can certainly have a decent red bandstand. I also very much approve of the Loch Ness Serpent. It places Old Nick firmly where he belongs, North of the Border, and at some depth.

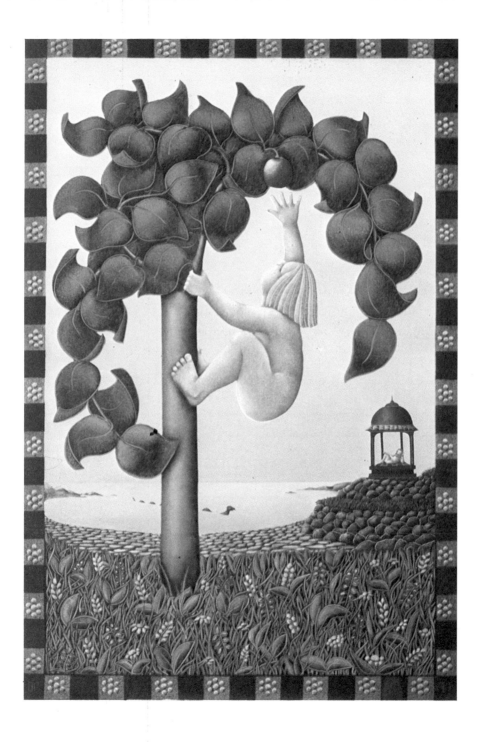

NAMELESS

"Mrs Castle again, and once more with an interesting new sidelight on an ancient legend. Of course, when Eve was created out of Adam's rib, she would not have been a full-blown woman. She would have been a little woman (hence, perhaps, the phrase), an Action Woman. Then she would have grown. There is a possibility that she was the World's first inflatable woman."

Another small joke wasted. Mrs Bradley was not the ideal partner for this exercise.

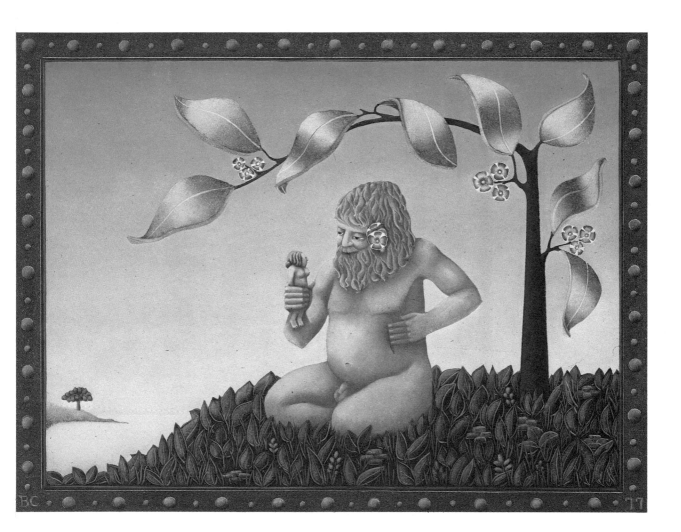

LESLIE SMITH

SNAKE BY THE WATER

I had to look at this picture several times before convincing myself that it was not a photograph culled from the *National Geographical Magazine.* It's an amazing piece of work, and less and less of a photograph the longer you look. The obvious give-away would be the flora — but being an urban gorilla that's lost on me — as Leslie Smith explains they come from far and wide. It's the reflections in the water that cheered me up. Pleasingly quirky.

Leslie Smith clearly has a low opinion of the Human Race.

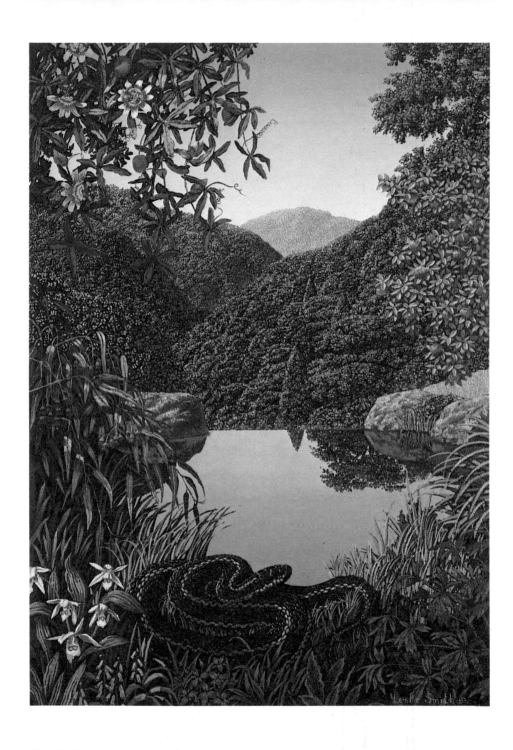

FERGUS HALL

EVE SUCCUMBS

"Fergie, it says here" I say "was born in Scotland. He very nearly fails to qualify as he admits to a smattering of art training, but this he swears he has rejected out of hand."

"Whose skull is that?" rasps Mrs Bradley, pointing dangerously with her umbrella.

"I can't imagine" I reply. "Nobody's died yet. Abel will enjoy the first funeral, but not yet. It's quite small. I imagine that it's some ape that the serpent has lunched off." I dive back into the catalogue. "It says here that Fergie's pictures reveal a humorous and grotesque imagination and he is linked to the small school of Scottish naive fantasists."

"Oh dear, oh dear" Mrs Bradley shakes her head sadly.

"I don't think it's illegal?" I say. "Sounds quite fun."

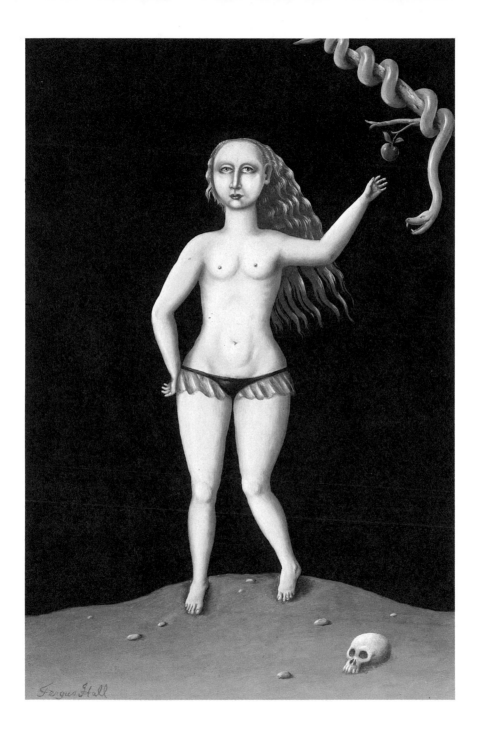

PETER HEARD

RETIREMENT ADAM

"Herewith" I cry "the Herd." I'm referring to the family Heard. The next three works.

"Now, they're nice" says Mrs Bradley, identifying heavily with Eve.

"That's Peter, the father. I feel that I've met that couple previously."

And I very much like the way he talked himself into doing them again.

"I constantly attempt at the planning stage to do something a little different as an escape from my normal imagery. We are all influenced from childhood by typical biblical pictures and this influence is hard to shake. Coincidentally I saw in the *Radio Times* a sickeningly smug advert attempting to sell pension insurance. The picture was of an old loving couple posing in front of an idyllic rose-covered country cottage happy in their financial security. The painting idea then clicked into place. Transpose from the start of life to the end of life and Adam and Eve are still in the apple tree garden of the cottage called Eden having survived all their personal trials and tribulations. It's then just a matter of painting by numbers."

Good numbers, though, and catchy.

"He is a civil engineer" I read "and started painting in his 30s. He also has remarkable daughters. Please turn over."

And she did, causing an ancient commissionaire to whistle.

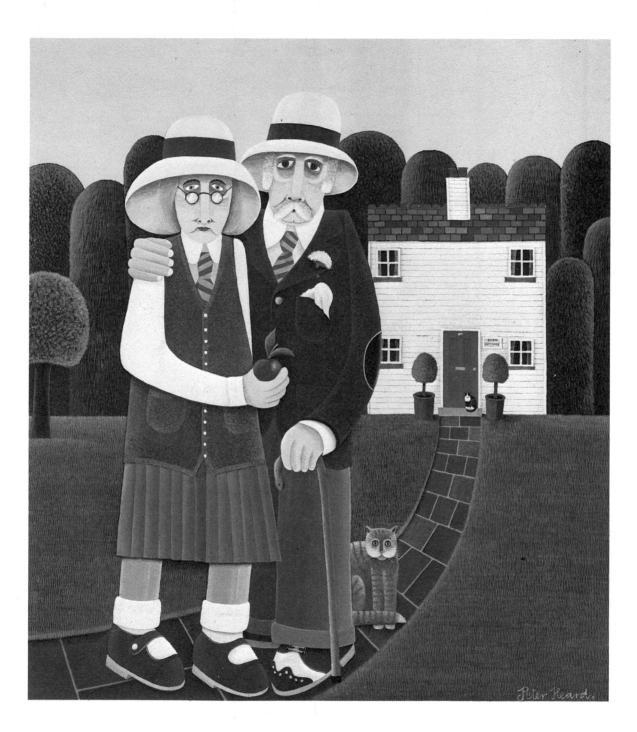

Peter Heard.

LAURA HEARD

TAKING TEMPTATION

"This is daughter Laura, and when she painted this she wasn't even a teenager. It makes you sick. It says here that both daughters are heavily influenced by father."

"Well, they would be."

"They use his paints and brushes."

"That's why they paint like him."

"I'm not arguing with that, though I think they influence each other more. Even then Laura goes for a rather sleek Adam and a long, blonde Eve while Sarah..." I look quickly about, I don't want Mrs Bradley doing that again — "Please turn over..."

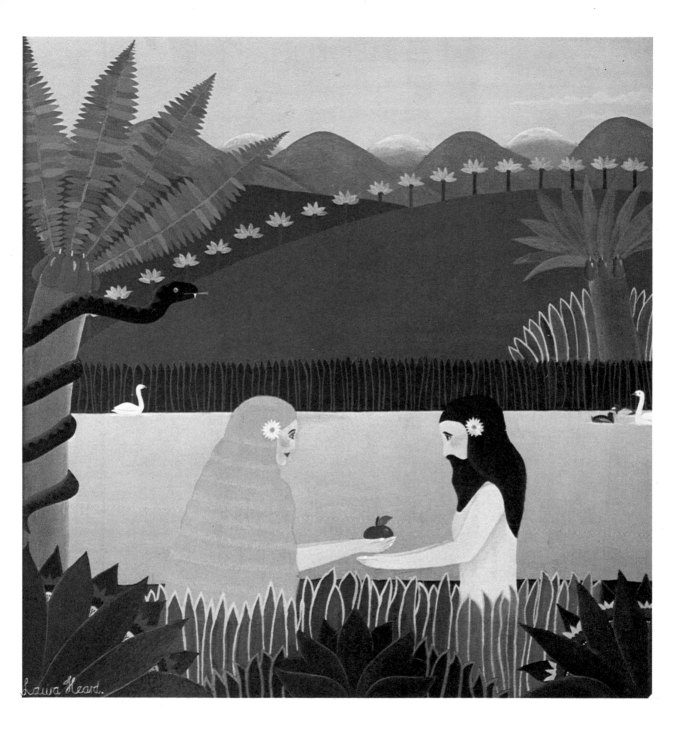

SARAH HEARD
IN THE SWIM

... while Sarah goes for a thickly-curled Adam and ginger Eve. They also have a very different line in palm-trees. I think they're wonderful. Not only for their age. They are not late starters, that's for sure.

This picture must be after the Fall. Adam is holding their costumes.

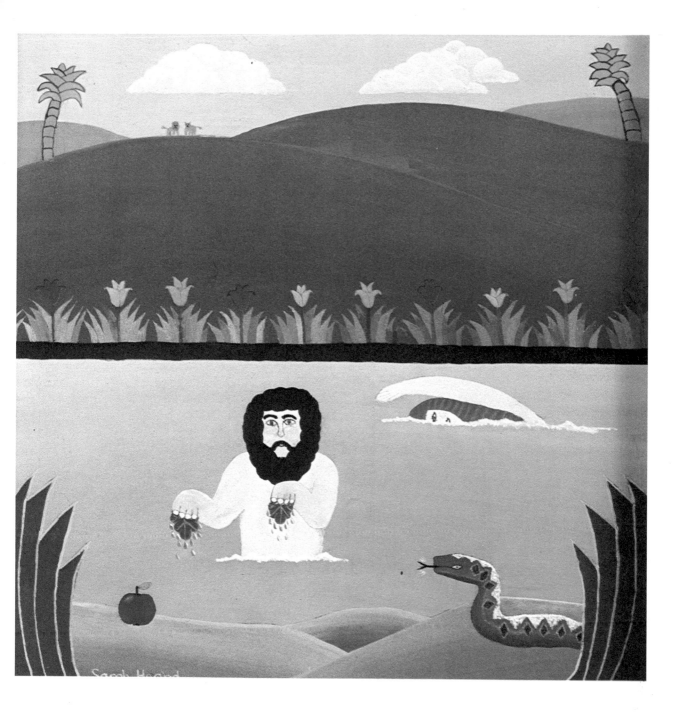

FELICITY BEVAN
ADAM AND EVE

"Paradise à la Capability Brown" I say. "Or Capability Bevan might be more apt."

"Delicious" says Mrs Bradley "Very English."

"Harken to Felicity a while" I intone.

"The actual/alleged site of the Garden of Eden seemed terribly arid, remote and foreign. How much more appealing, to me at least, that it should be in an English landscape with all its niceties and nonsenses. Shakespeare's 'other Eden, demi-Paradise'. The Fall hasn't happened yet, the apples are not quite ripe and the viper waits. Does it all sound a little lacklustre? How tedious it must have been living in a state of perfection since the dawn of time. Sin must have added quite a sparkle."

I am seized with an urge to burst into verse. I clutch Mrs Bradley by the lapels. I'm an aggressive poet, when moved.

"O Praise the Lord, for introducing Sin,
Paradise was Tonic, without the necessary Gin."

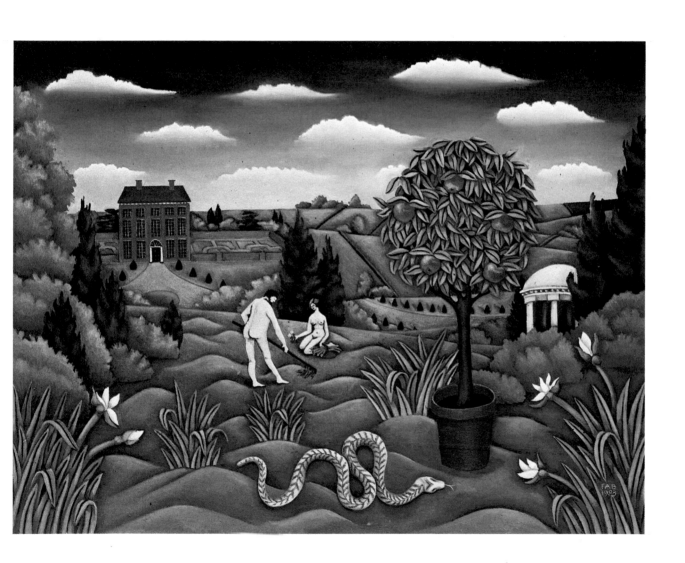

ROSEMARY FAWCETT

"Rosemary Fawcett" I say "appears to have come up with a novel and brilliant replacement for the double duvet. I must get my wife to rustle one up."

"What a handsome couple" says Mrs Bradley.

It's my turn to blush.

"No it isn't" says Mrs B "I am referring to Adam and Eve."

I agree. They make a striking pair. I like the colours very much.

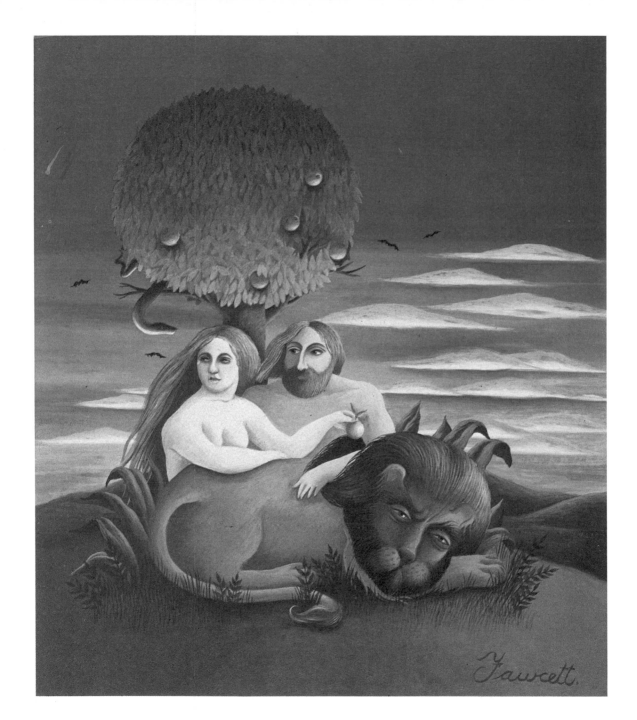

DAVID CHEEPEN

PARADISE LOST

"Now David Cheepen has studied the geography, that's very much as I imagine Eden."

"Where is the bouncer?" asks Mrs B.

"Crouching behind the gatepost, he's not keen on being portrayed. Or perhaps being an Angel of the Lord, invisible." She's none too pleased. She doesn't understand artistic licence — so I read her David Cheepen's commentary.

"I have depicted Adam and Eve emerging from the Garden, naked and vulnerable, into the wilderness, just as each of us leaves the security of childhood innocence only to enter his own personal wilderness ... as mankind itself, perhaps, has lost its collective innocence and has entered its collective wilderness."

"There's cheerful" says Mrs B.

"But true", I reply "but true."

Mrs Bradley is bemused.

"Adam and Eve stand waiting in the wings for their entrance in the first performance of the Creation. Being an exceptionally cold day, neither of them is prepared to wait around in the nude and Eve insists on having her umbrella in case of threatening weather. Several clergymen dressed in white coats are acting as stage hands, adding the last minute touches to the scene. The wardrobe assistant has just finished the final fittings of the fig leaves. Standing on the end of the park bench God suspends fruit and vegetables in front of Adam to see which he is tempted by. As he is preoccupied with his experiments, God has left a statue of himself amidst his workforce to remind them of his omnipresence."

I admit that that is not my idea of God. It looks more like David Steel. Mine lies somewhere between W.G. Grace and Karl Marx. This is certainly not the Jehovah of the Old Testament, who had an appalling temper.

I like the theatrical notion of their waiting to go on. Act I, Scene I: Eden. Is Eve suitably dressed for emerging from Adam's side, the umbrella could do him a permanent mischief. But there are the fig-leaves!

"Not yet" cries the director, who is doubling as the serpent.

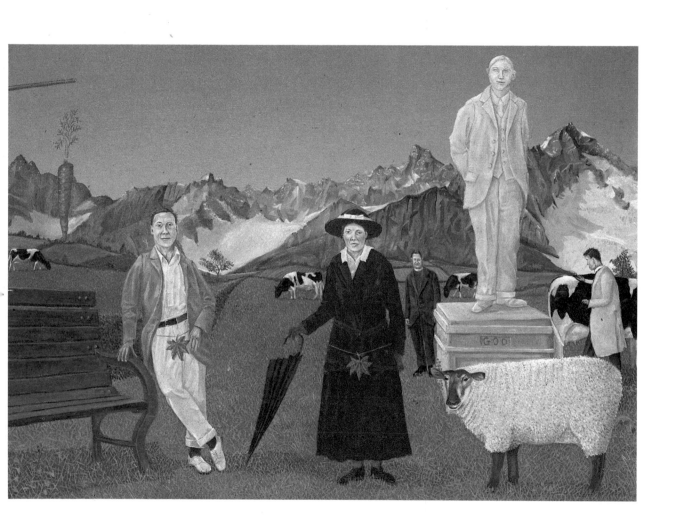

REGINALD PEPPER

ADAM AND EVE

"What a splendid scene!" I cry. "Now there's primitive." Mrs Bradley likes the frame and the obviously dominant Eve.

"Pepper is with you on that one" I reply. He says:

"I have decided to show Adam and Eve after the Fall. They have been expelled from the Garden of Eden, thus it is always winter. Cain and Abel seem to be quite enjoying themselves having a snowball fight, blissfully unaware perhaps of their parents' sin. Spot the dog is shivering in the cold. It is obvious that Adam is and always has been entirely under Eve's thumb — she definitely wears the trousers."

No, she doesn't, but once again the fig leaf has been avoided. Precious few so far have tackled that problem, indeed most have made a conscious effort to avoid it.

I'm sure Cain and Abel were blissfully unaware of their parents' sin:

a) parents aren't going to pass that sort of information on and

b) 'Genesis' isn't yet on the bookstalls.

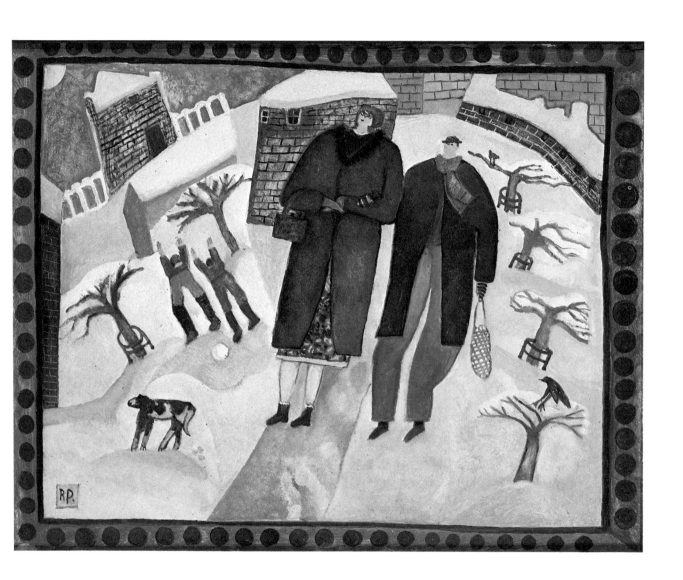

"Poor Mark Copeland. Depressed and bewildered by the Adam and Eve story, though give him his due, his angels are quite cheering. I never fancied an eternity of white kaftans and harp-playing."

"You won't be going up there" Mrs B shakes her head vigorously, and points at the floor with her umbrella.

"It must be very over-crowded" I reply "which is why I tend towards Reincarnation, but that's another story. Here's Mark Copeland's":

"In the Adam and Eve picture I was trying to express the feeling of oppression and despair that the text of Genesis gave me. The expressions on Adam and Eve's faces are not supposed to be fear so much as having been tricked into doing whatever it was they were supposed to have done without much chance of escape. The odds were against them being able to stay in Paradise."

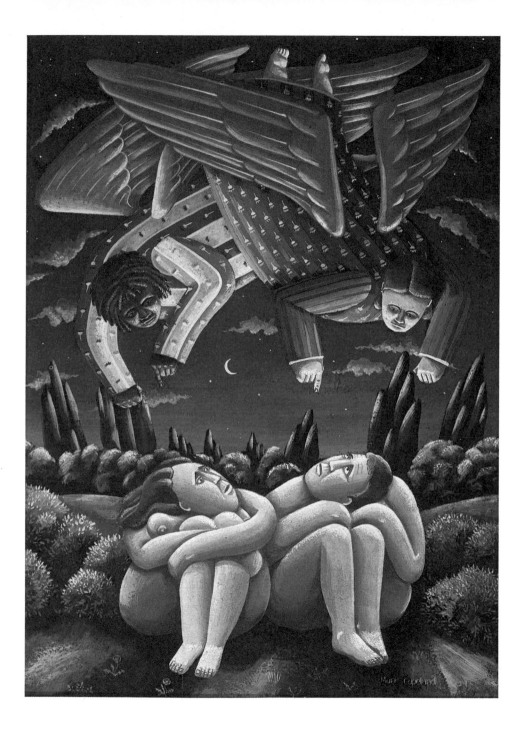

JANET WOOLLEY
THE FIRST PARENTS

"Look at those eyes" says Mrs B.

"You can't miss them," I say. "In the norm I don't pay much attention to them, that's the cartoonist in me, I dare say, but I find the rest of the face far more revealing. You can always put dots for eyes. She was a trained water-colourist from the Royal College of Art, until the Portal pressed her into oils. Thence she has never looked back."

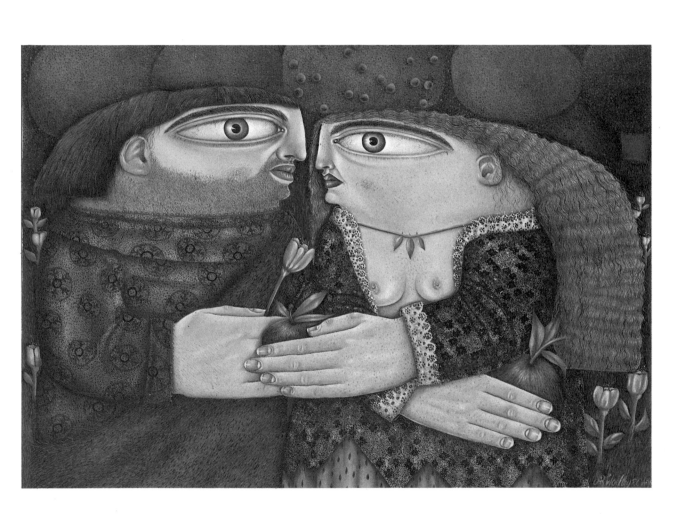

"I think she's a bit hard on Adam" I say, thumbing through Lizzie Riches' commentary. "Perhaps" I add, lowering the voice carefully "she is a feminist." I'm certainly not making accusations of sexism by saying how very pretty her Eve is, and I think I know her mother. I mean there was poor old Adam, out all day mulching and pruning and taming beasts, while she just lay there, pushing the plot along.

"I have chosen to depict Eve in the garden alone, because I think she is the most important character with more imagination than Adam. I see her accepting the fruit of knowledge of good and evil as a gift rather than stealing something, because there wouldn't have been much of a story thereafter if she hadn't!"

Great Question of Our Time: Would Eve have a navel?

Other Great Question of Our Time: Is there a Night-Life after Death?

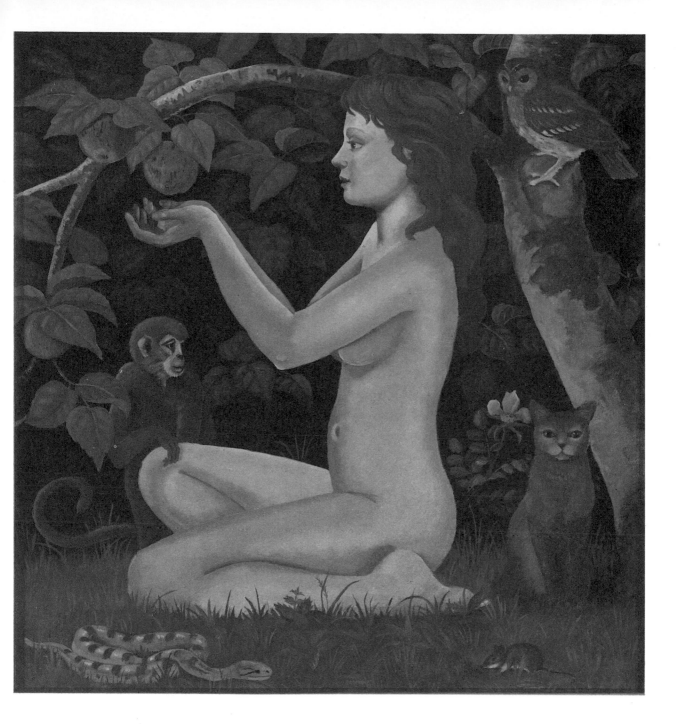

JAMES McNAUGHT

I must confess that I've enjoyed meandering through the Primitives. I think every aspect of Adam and Eve has been covered, from the Rise to the Fall, and Beyond.

Here is the Fall again, the precise moment. Eve has just taken her bite of the apple and Adam is already regretting his. The snake, you can just catch his forked tail, is vanishing back in to the tree.

It is the exact moment when Man said "Oh, shit!" for the first time, and James McNaught has captured it precisely. After months of Paradise, guitar-playing, light reading and exotic cocktails, now it's on with the fig-leaves and tweeds and out into the cold, cold world.

"And that" I say "goes for us, Mrs Bradley."

"What?" she growls, or was it the Doberman struggling down her trouser-leg.

"Time for the donning of fig-leaves and tweeds, and out into the cold, cold world."

Goodbye, Adam. Goodnight Eve. And do cheer up, it's not that serious.

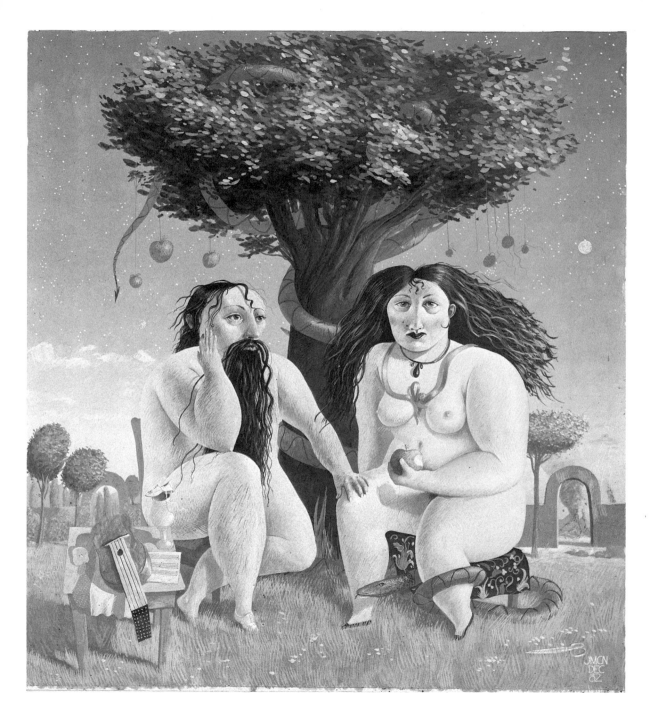